dog coloring book

dog coloring book

Copyright © 2018 Honovi Rex
All right reserved
ISBN: 9781792639449

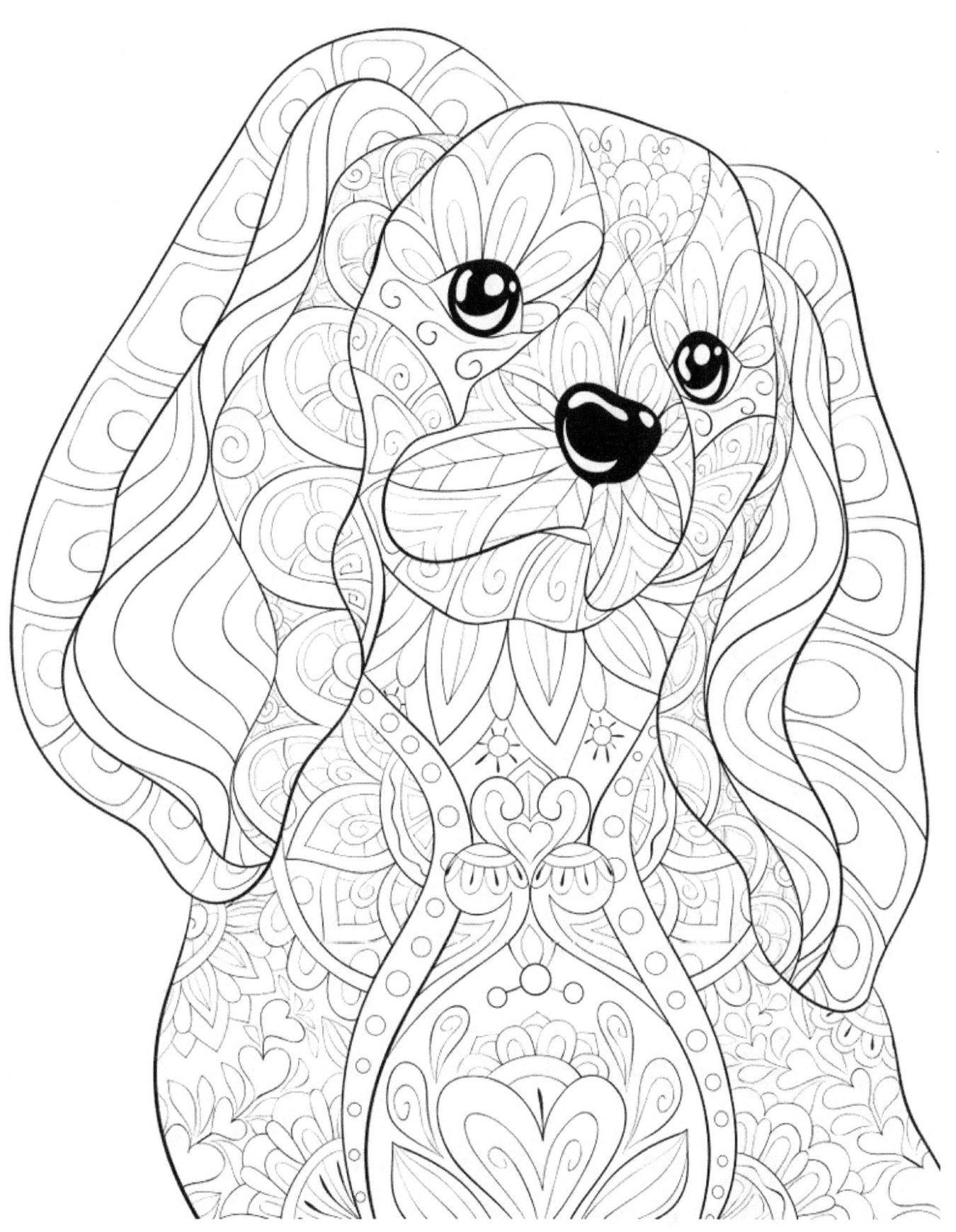

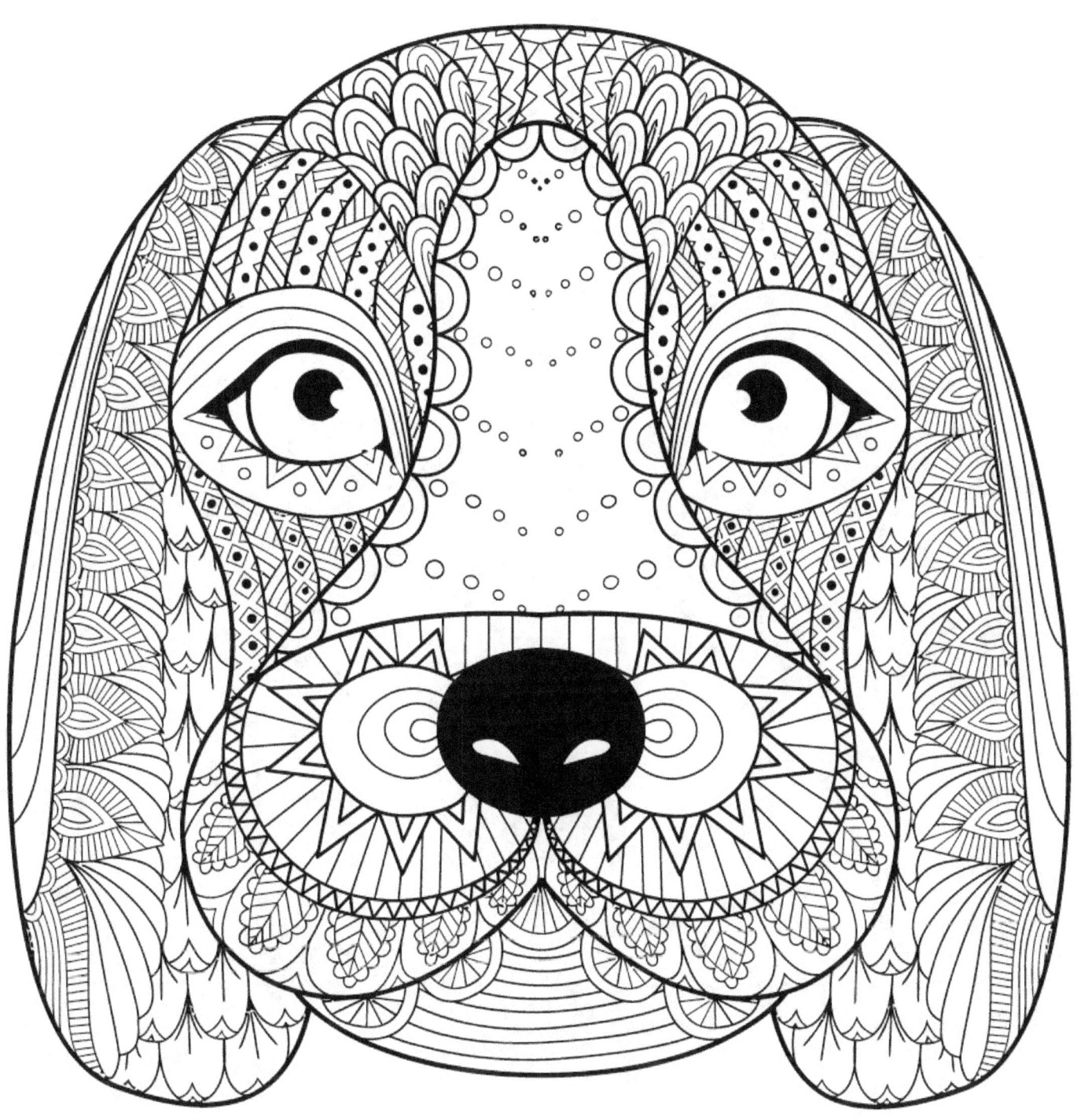

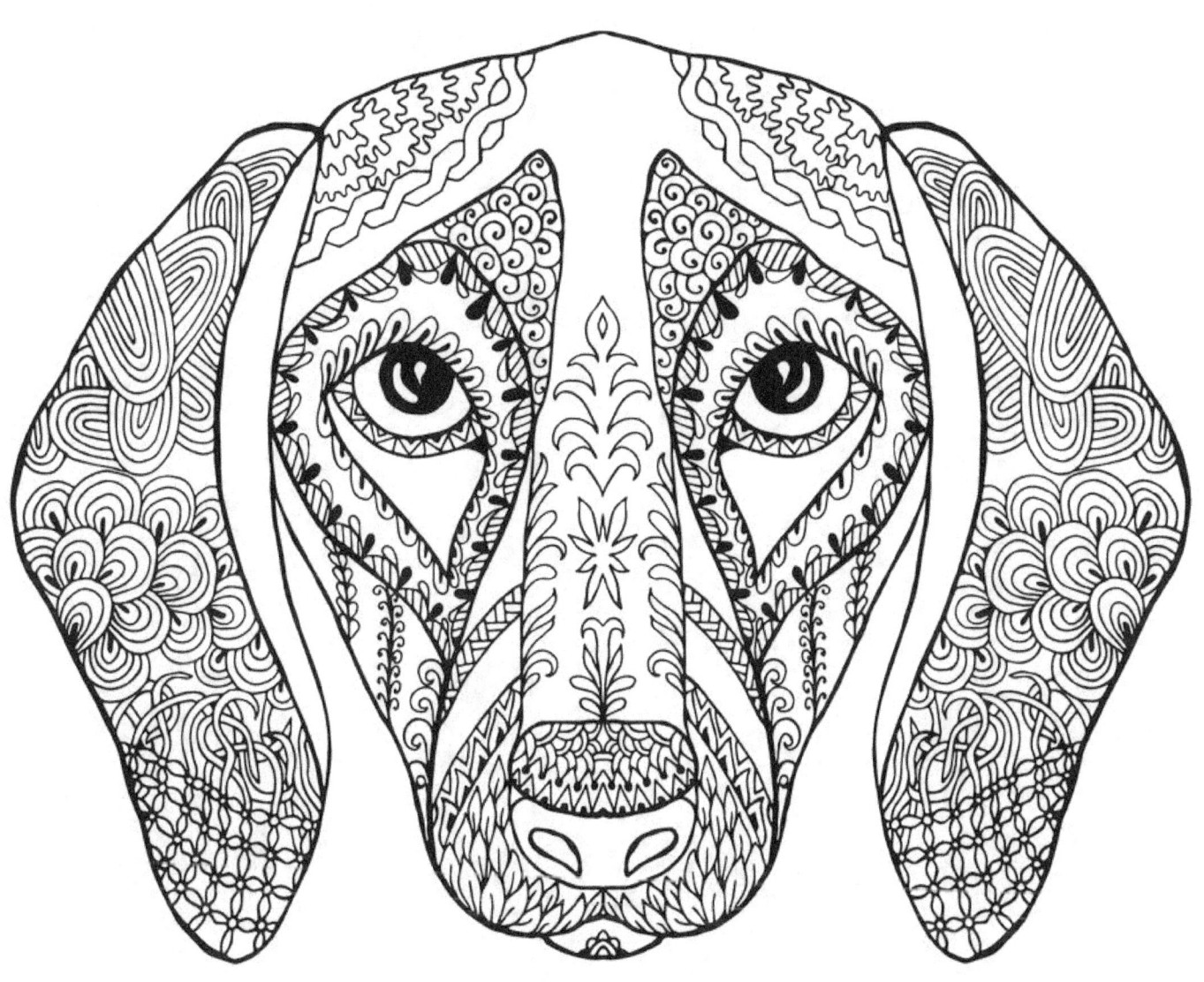

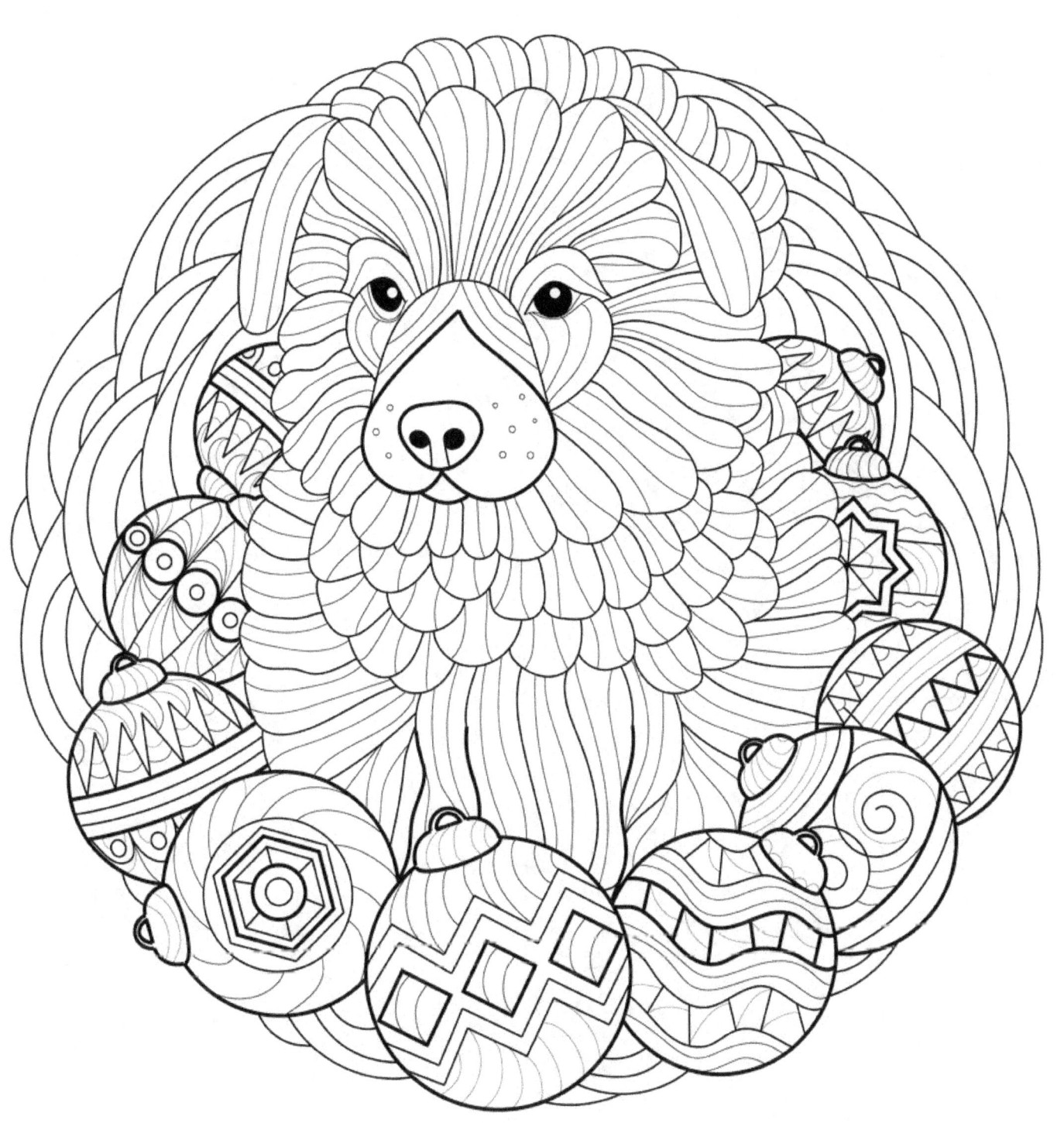

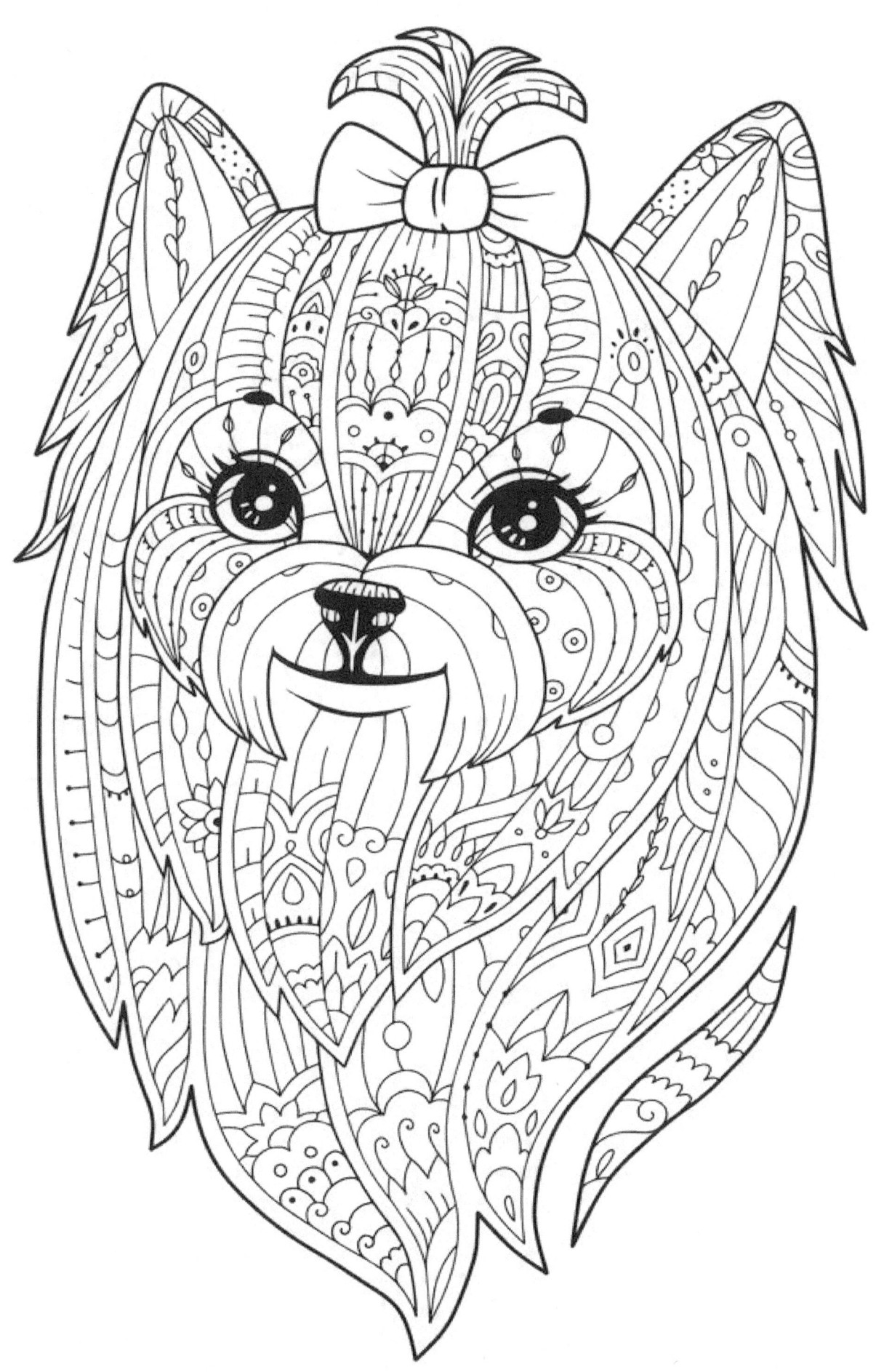

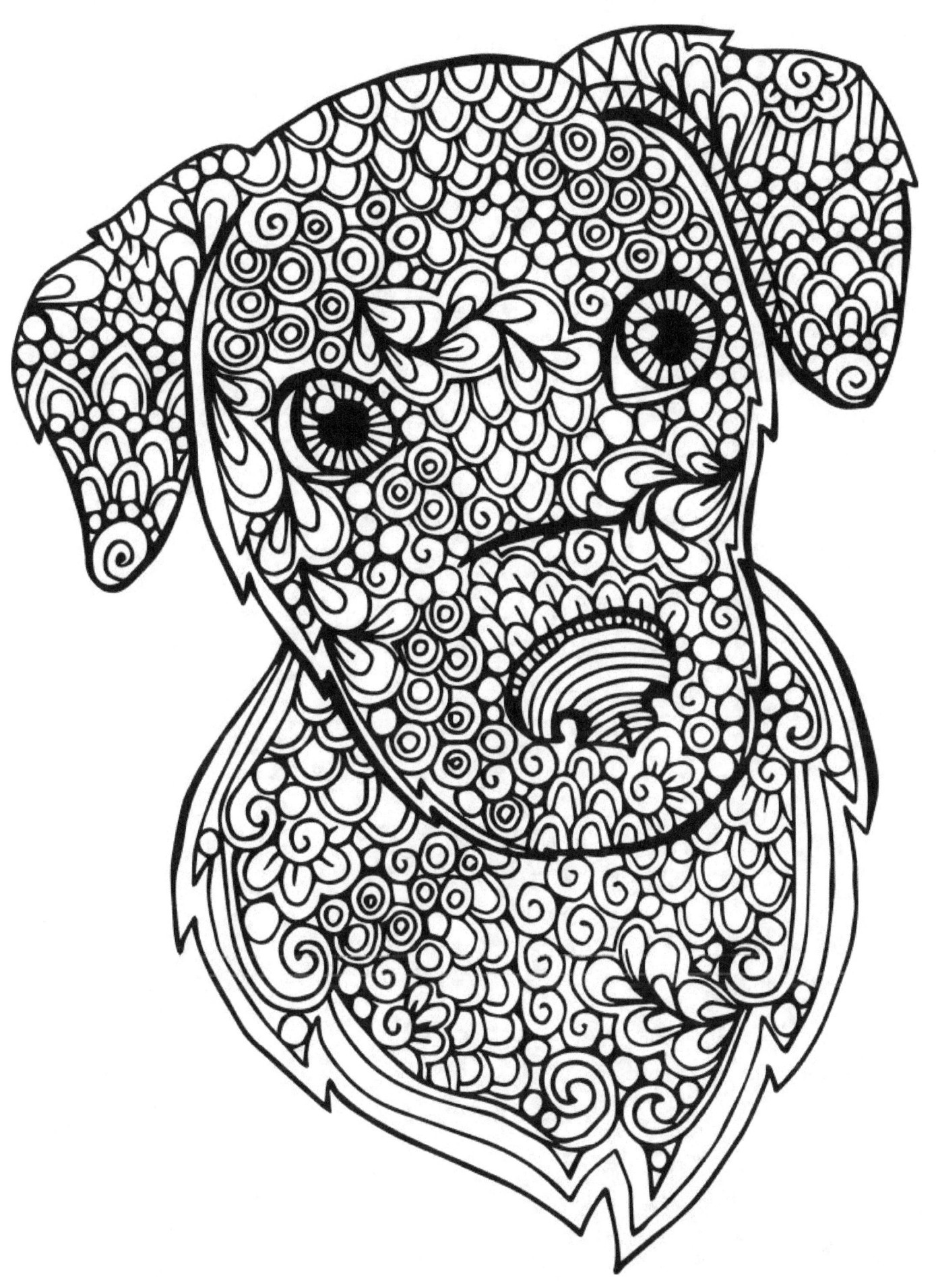

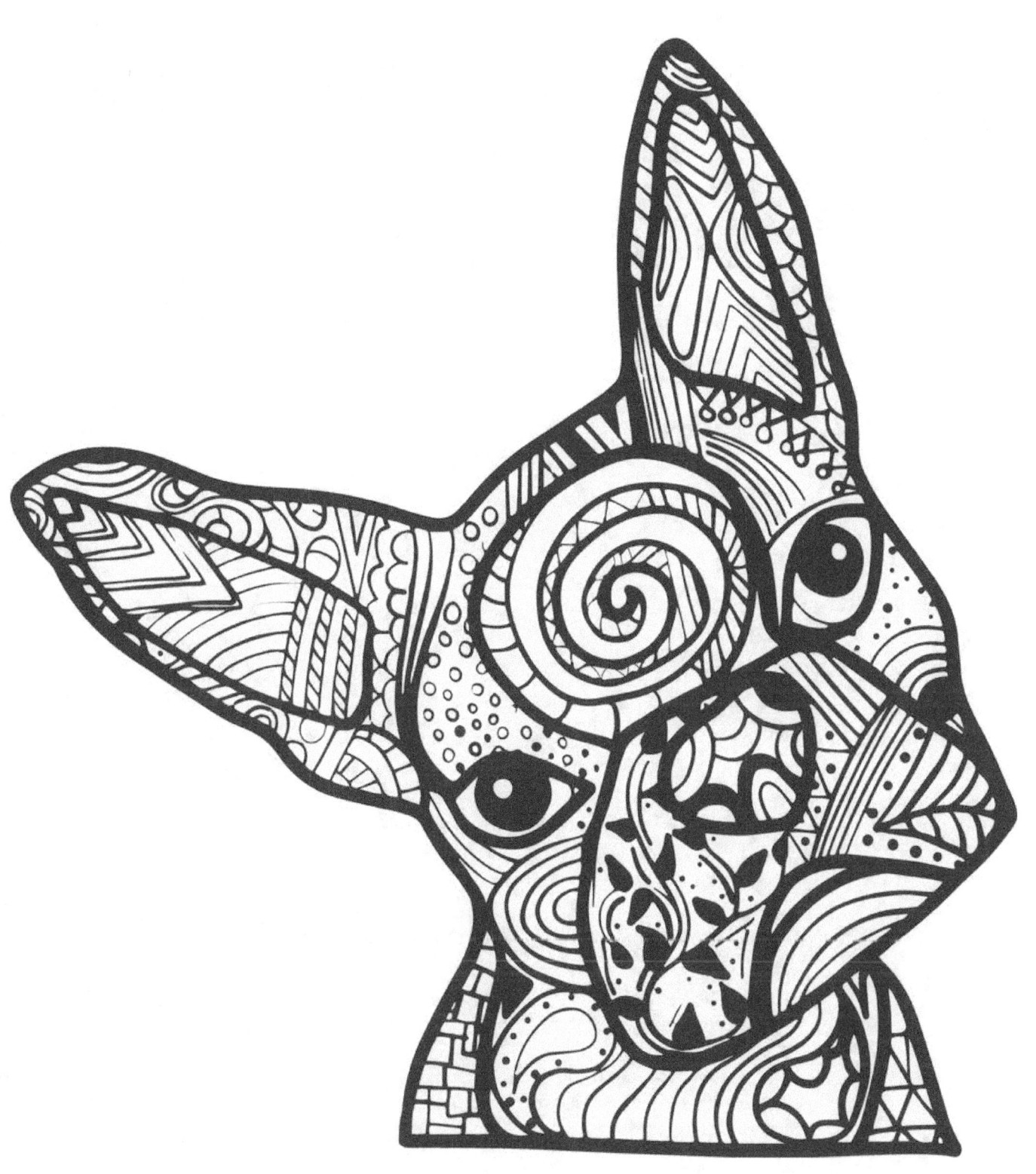

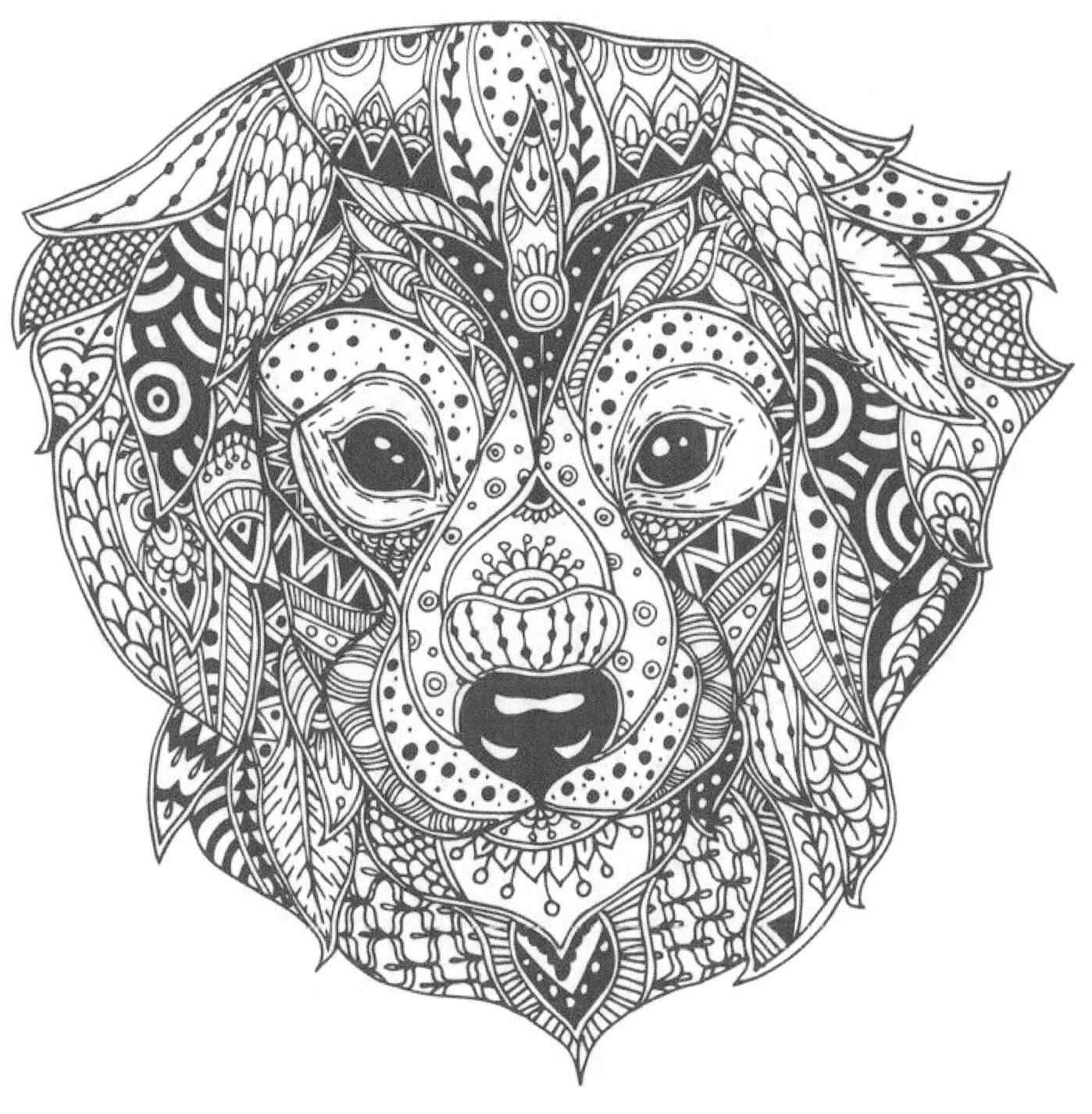

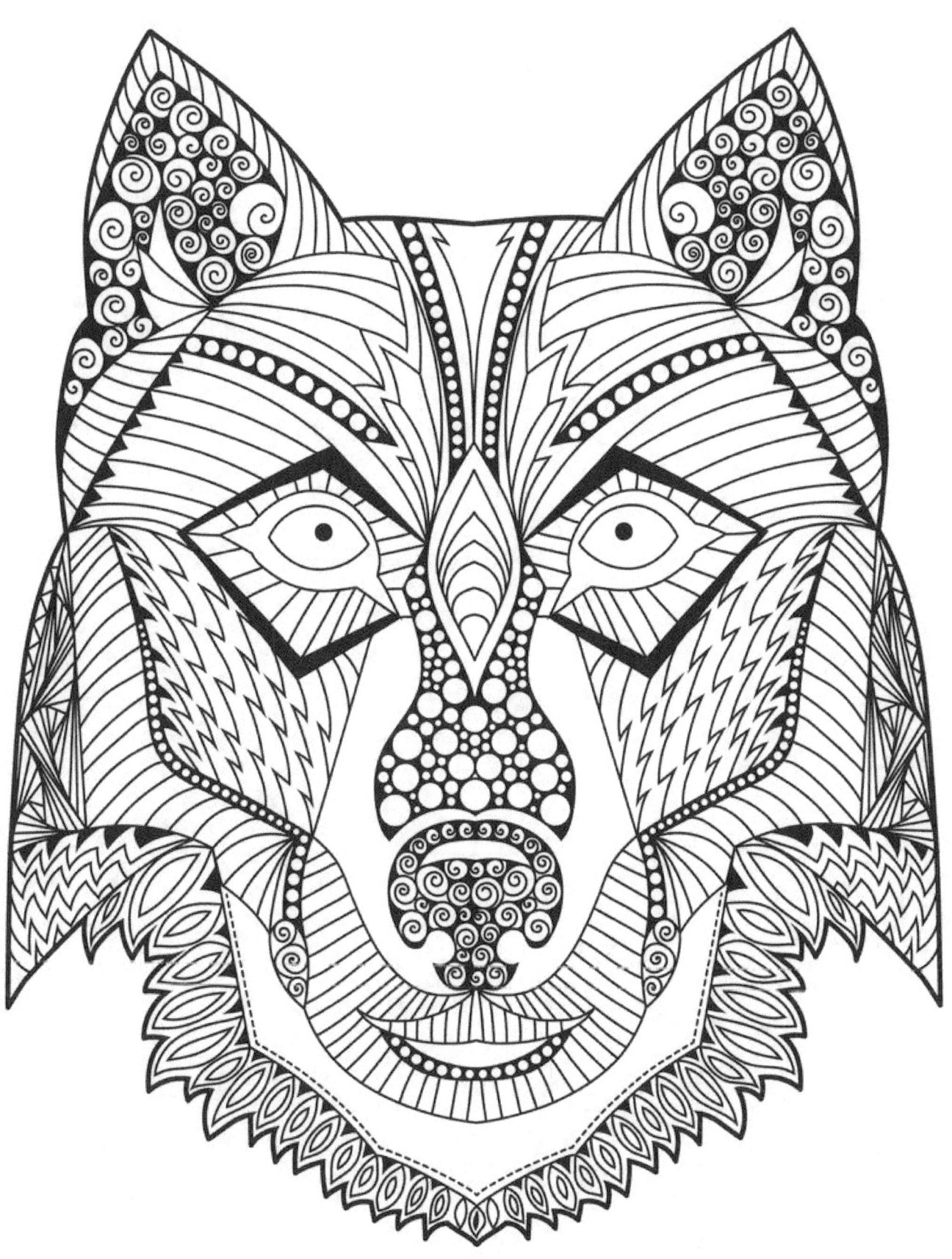

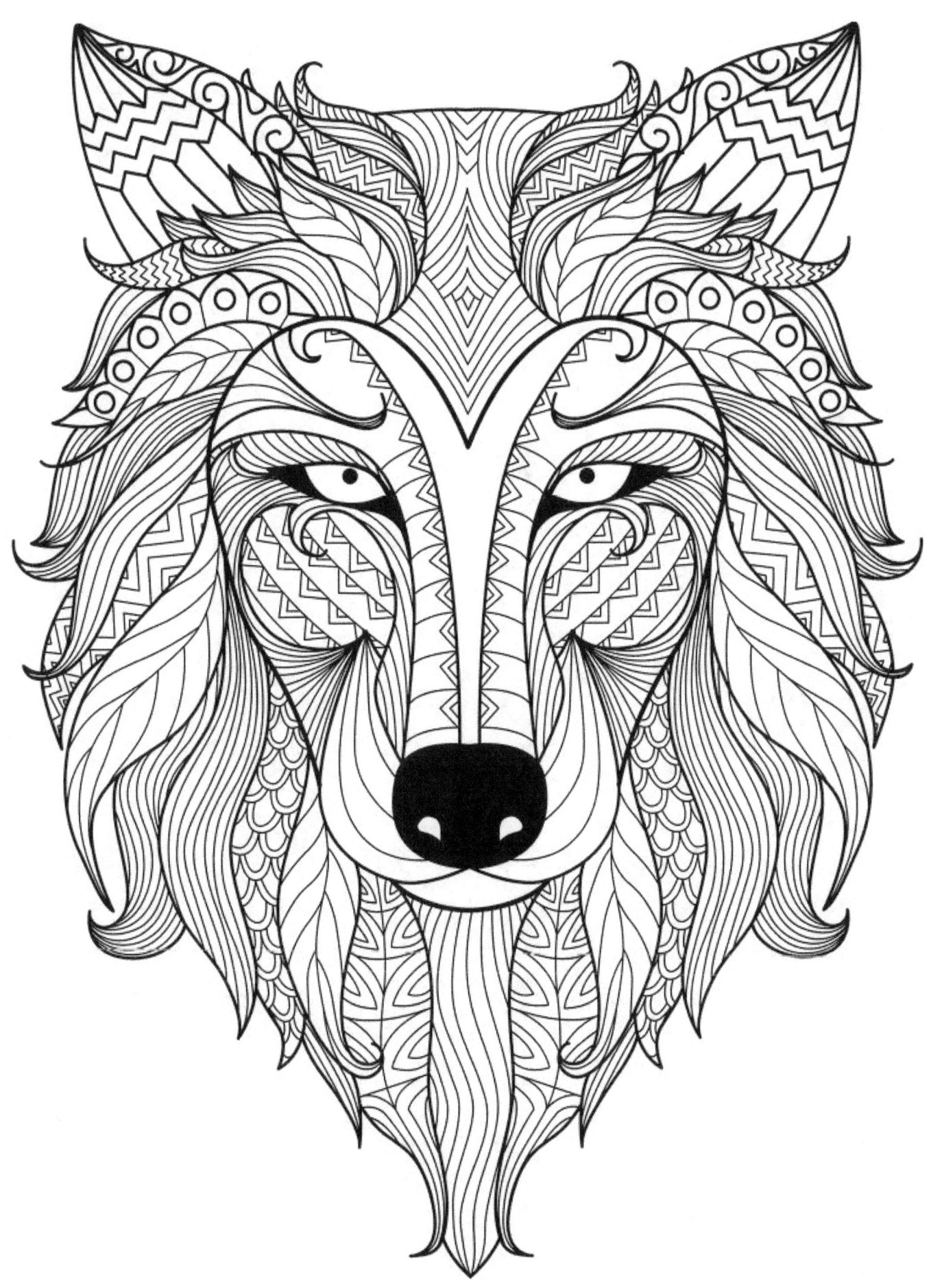

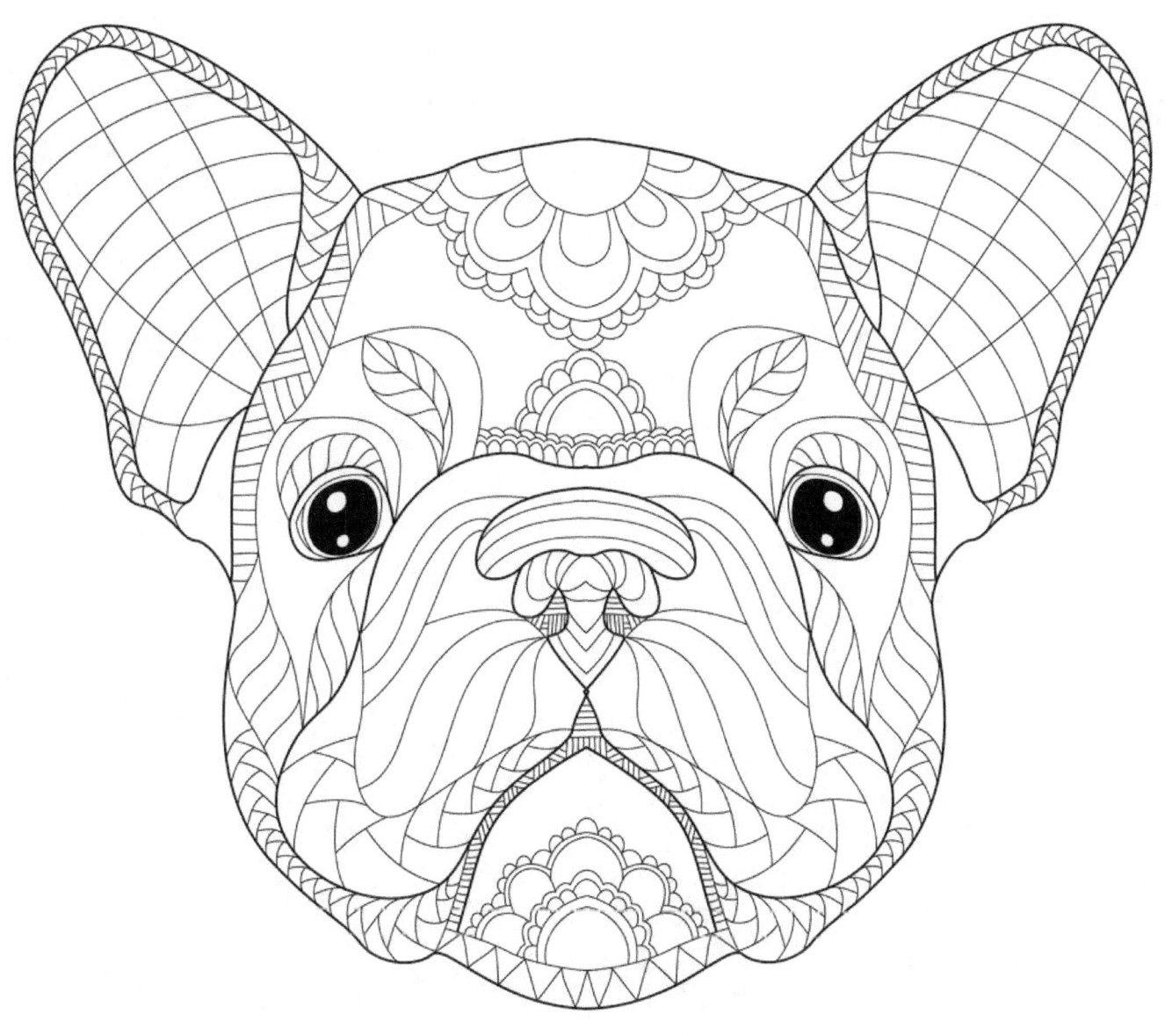

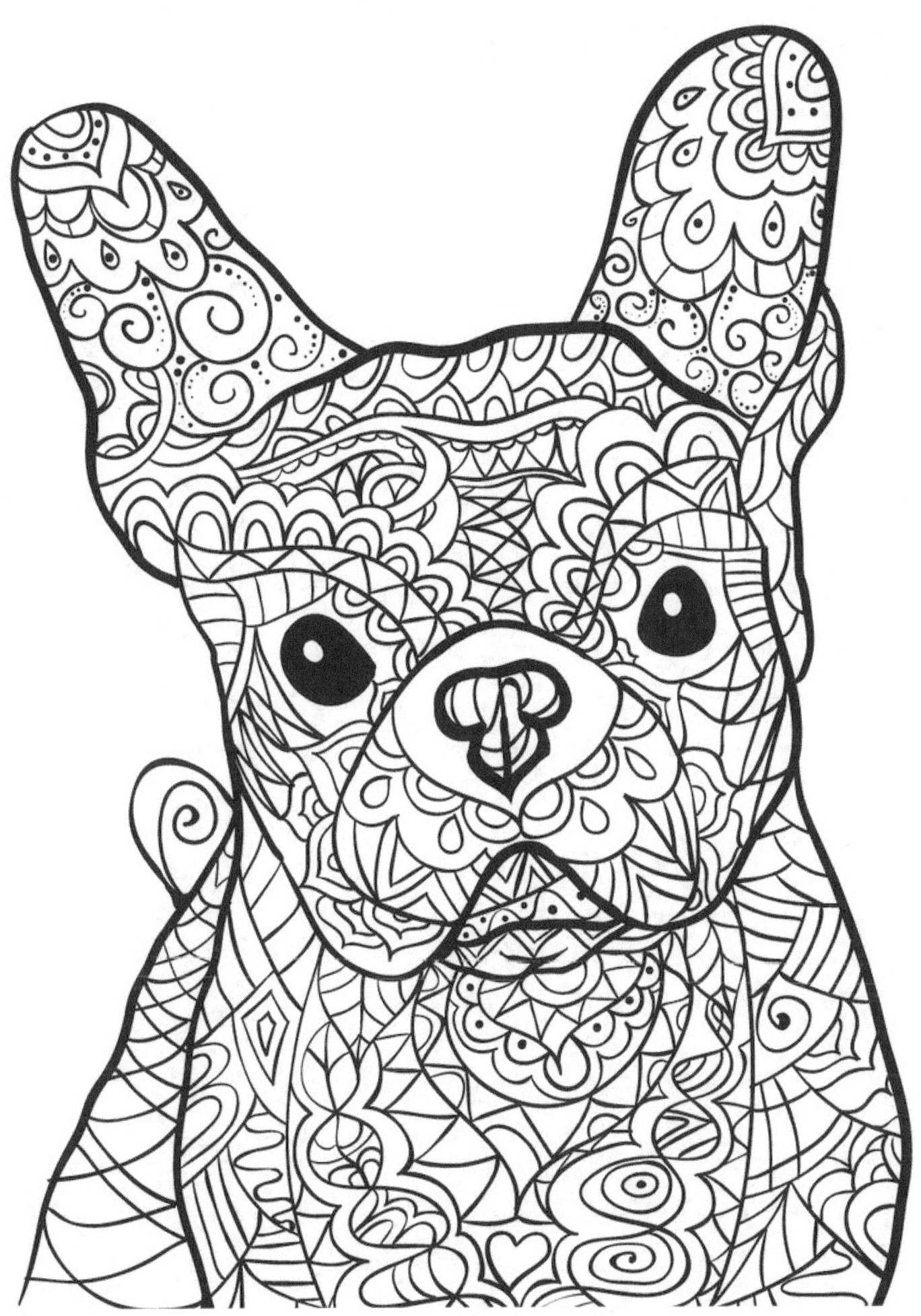

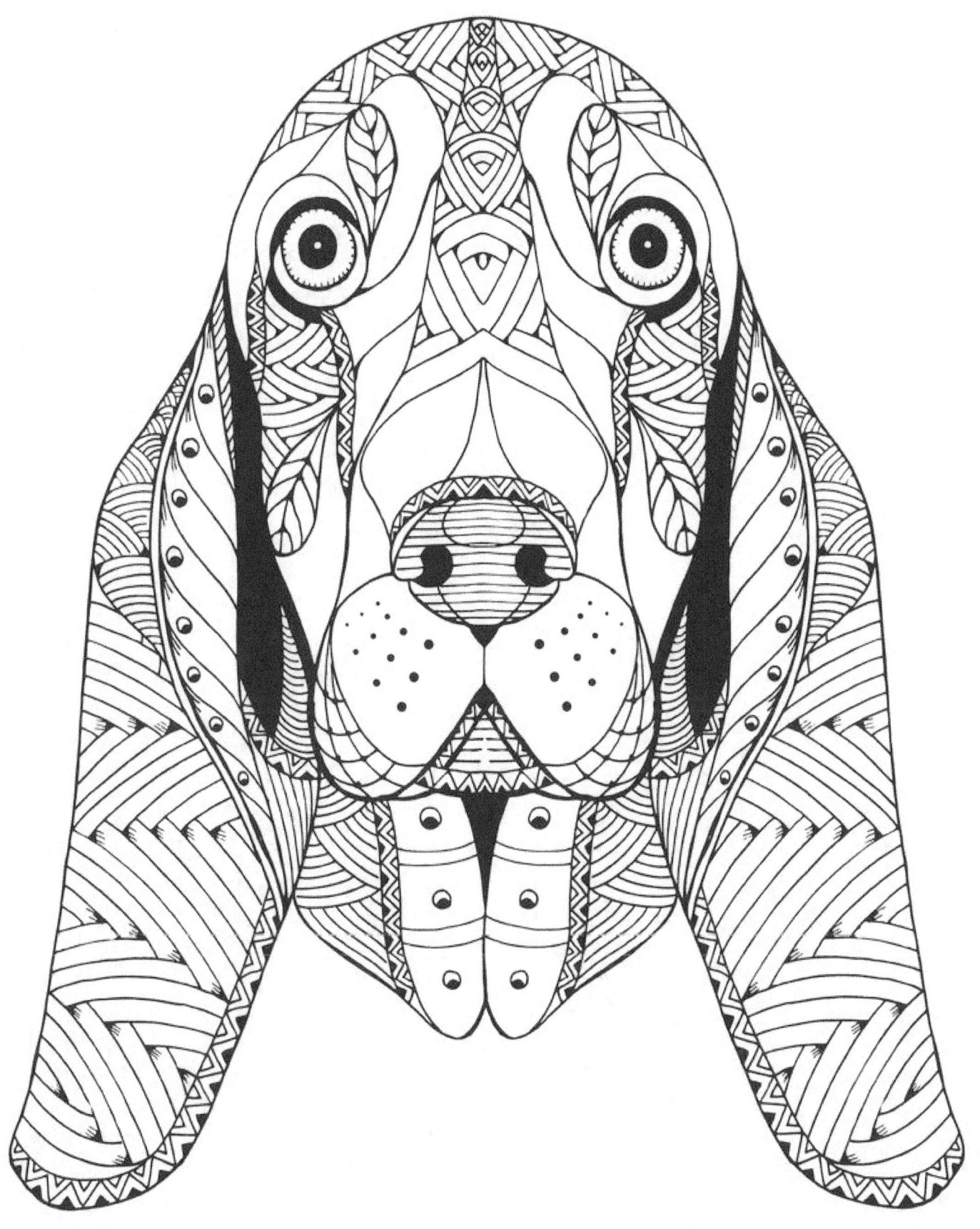

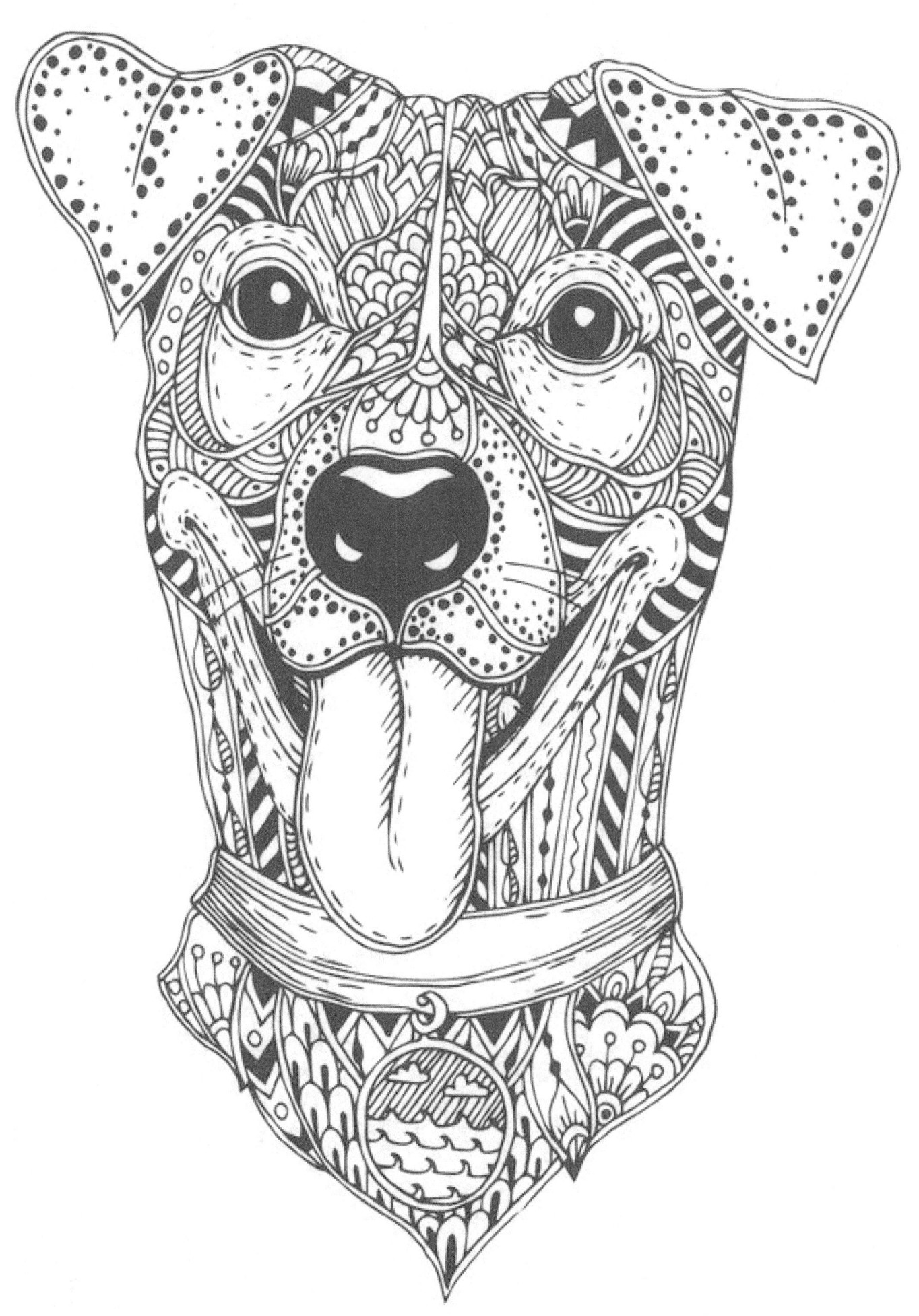

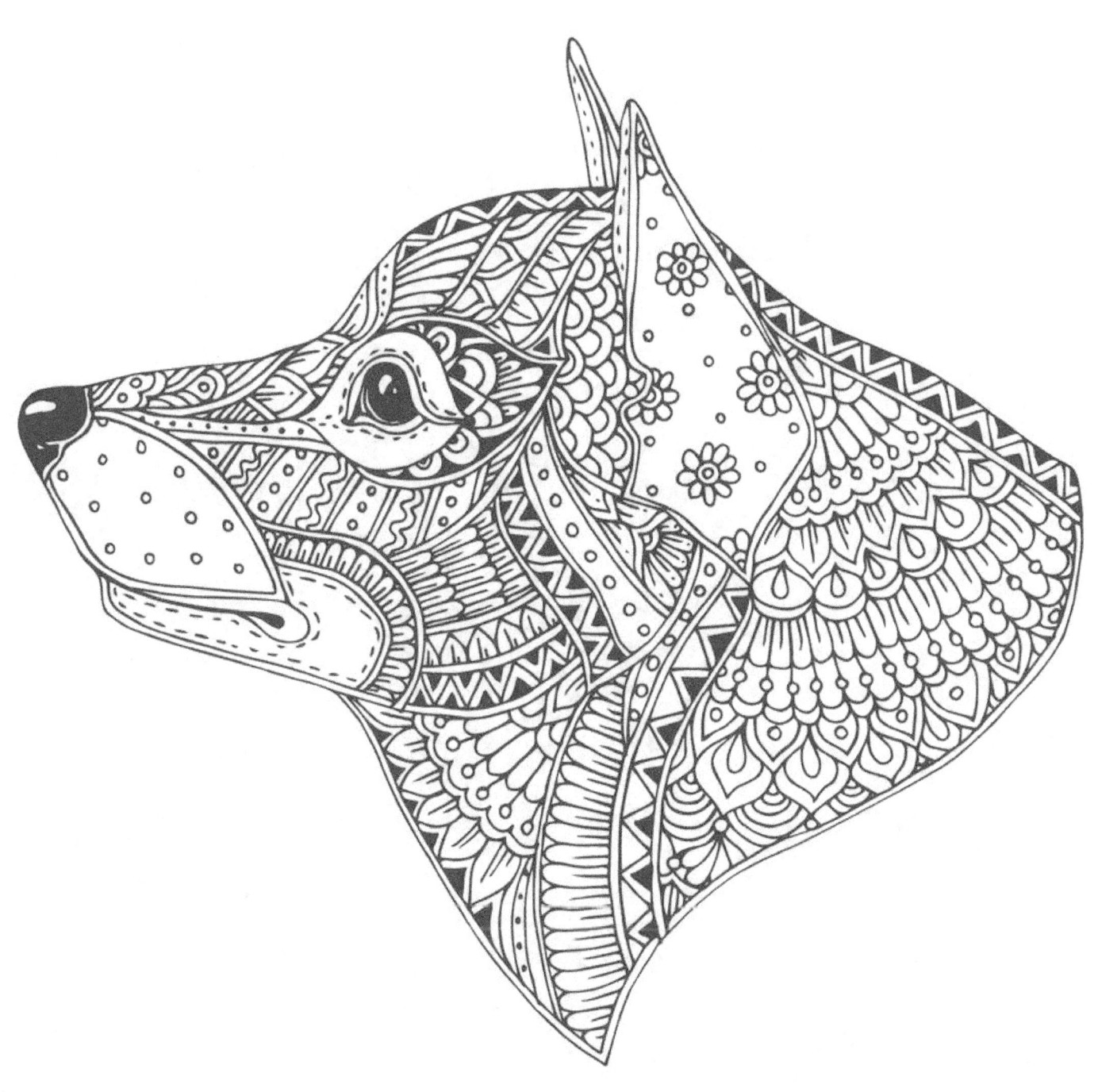

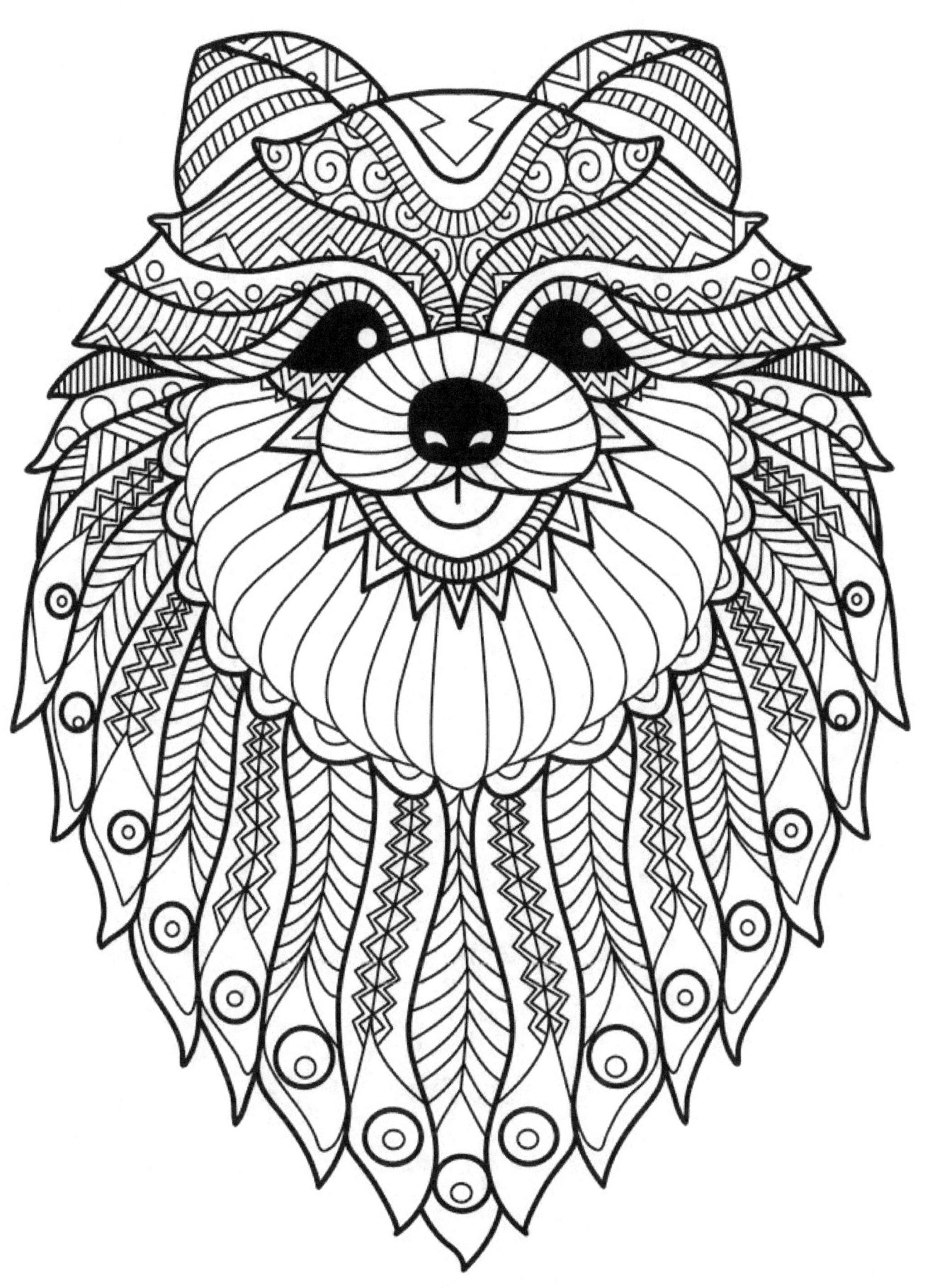

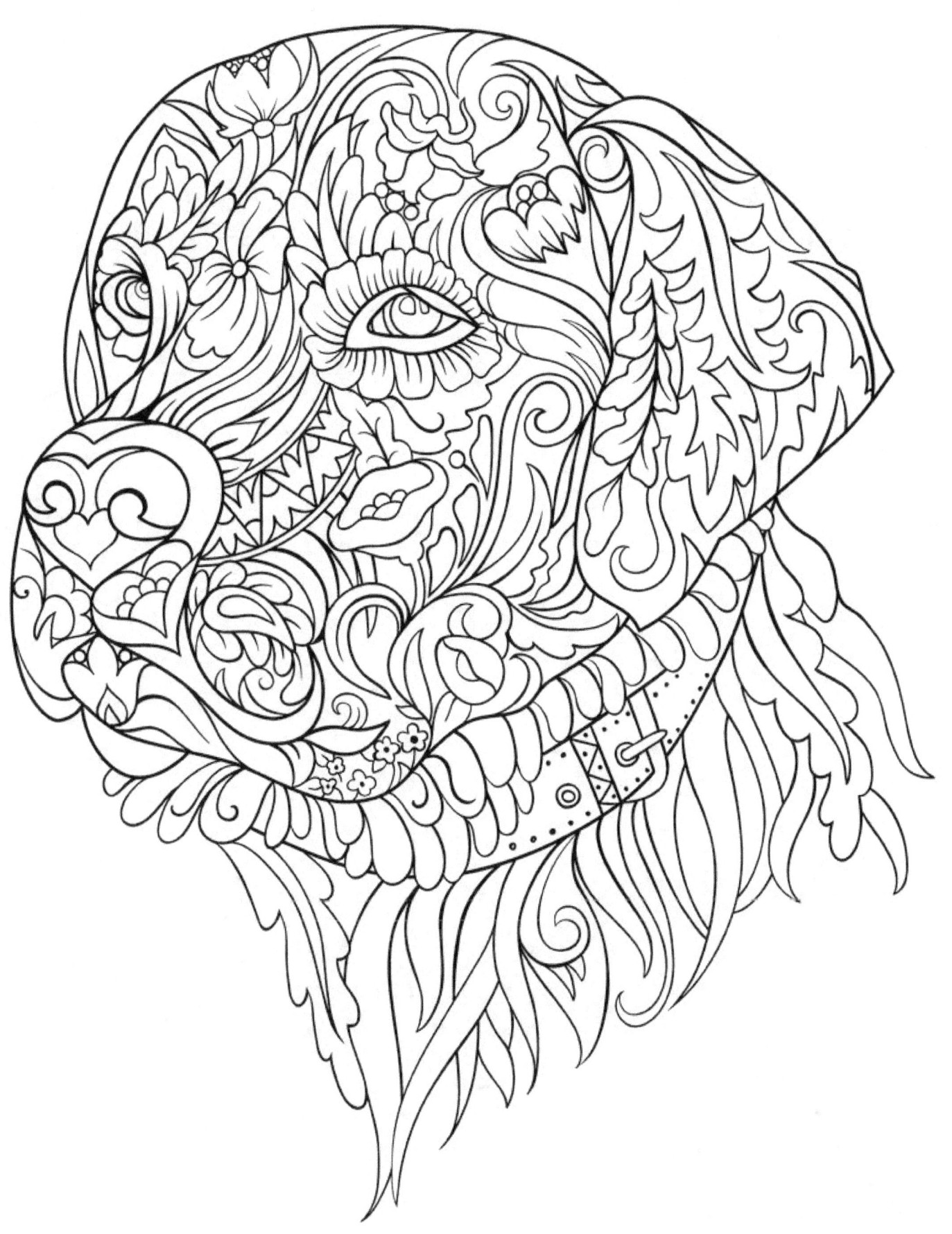

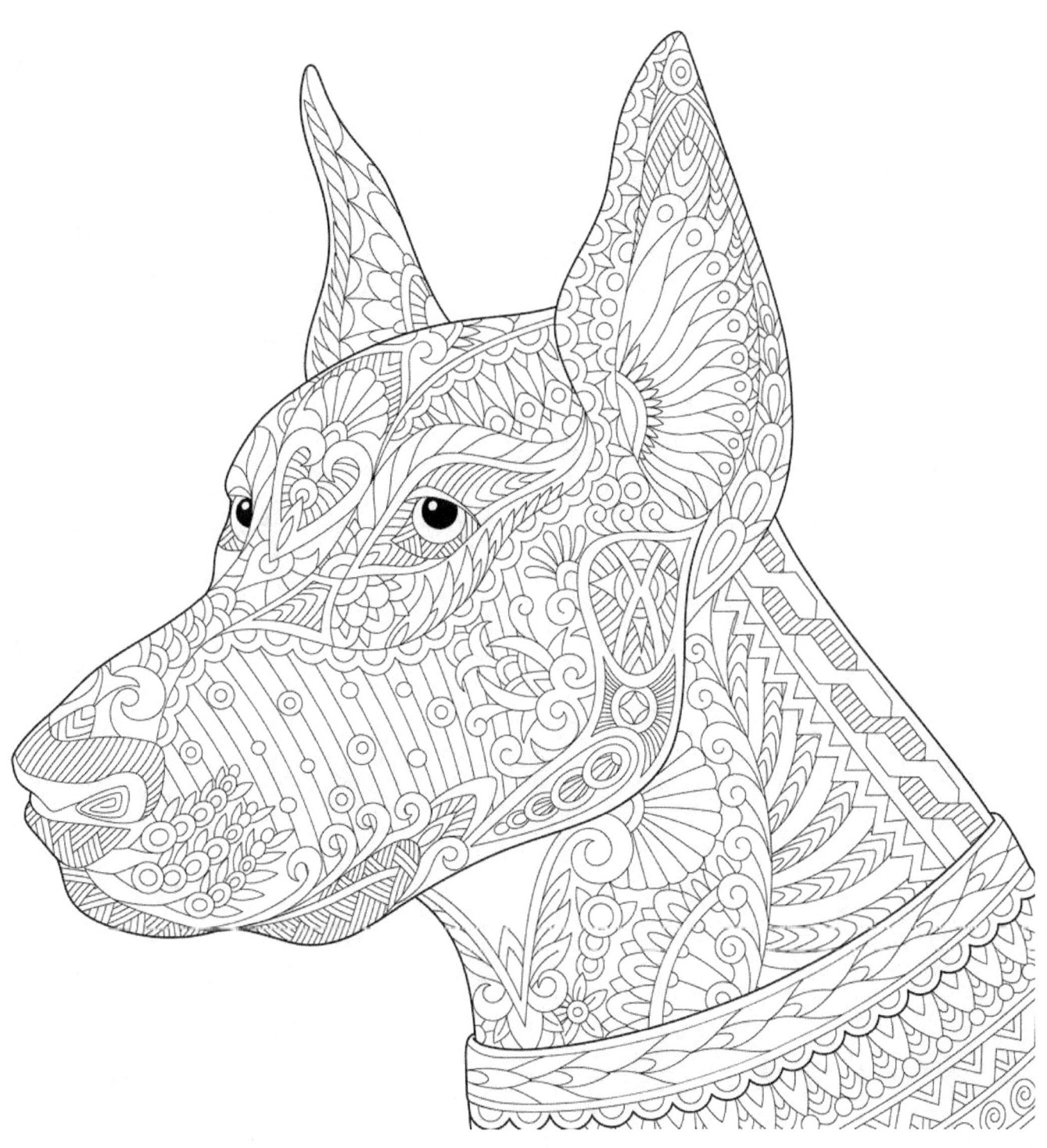

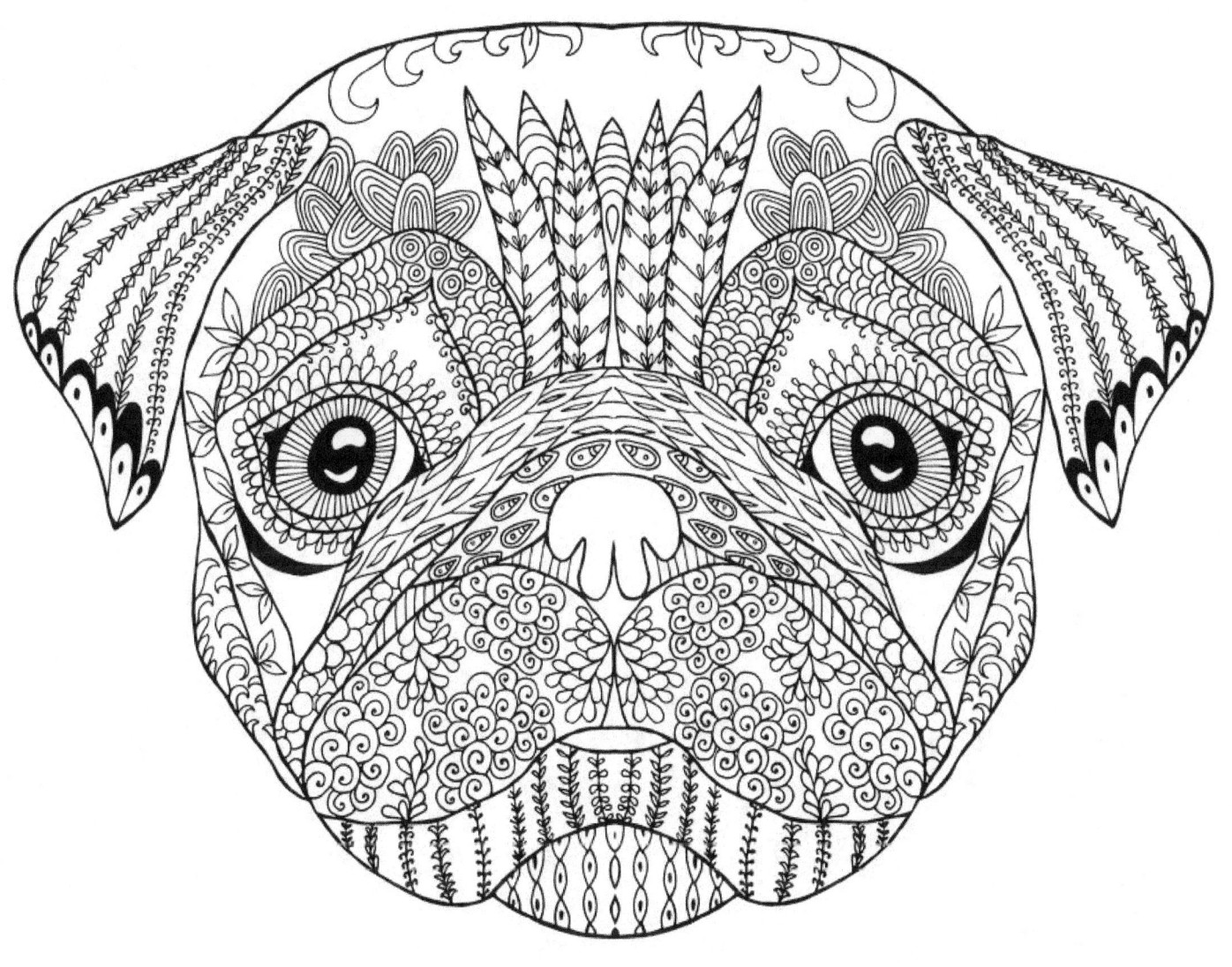

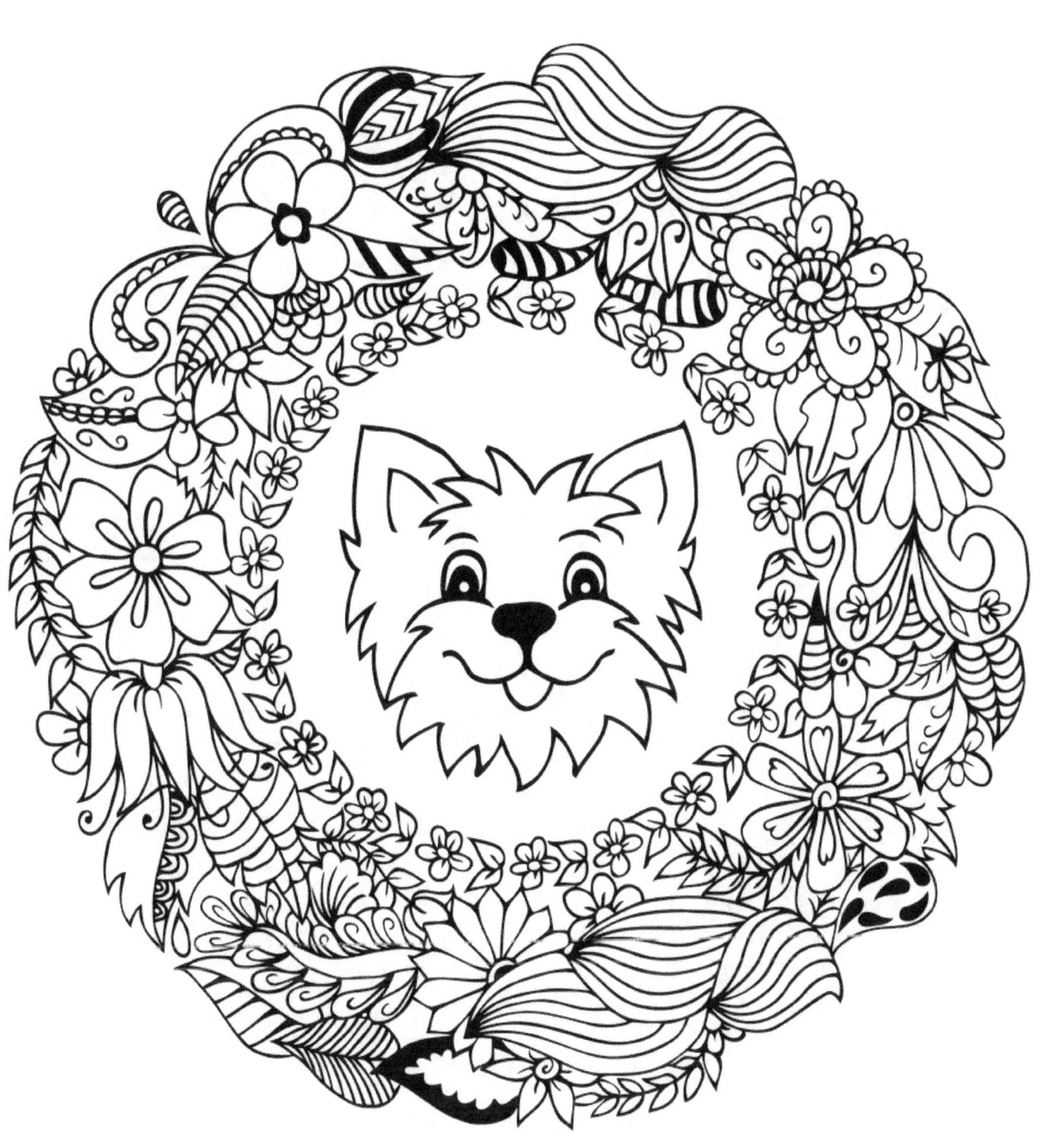

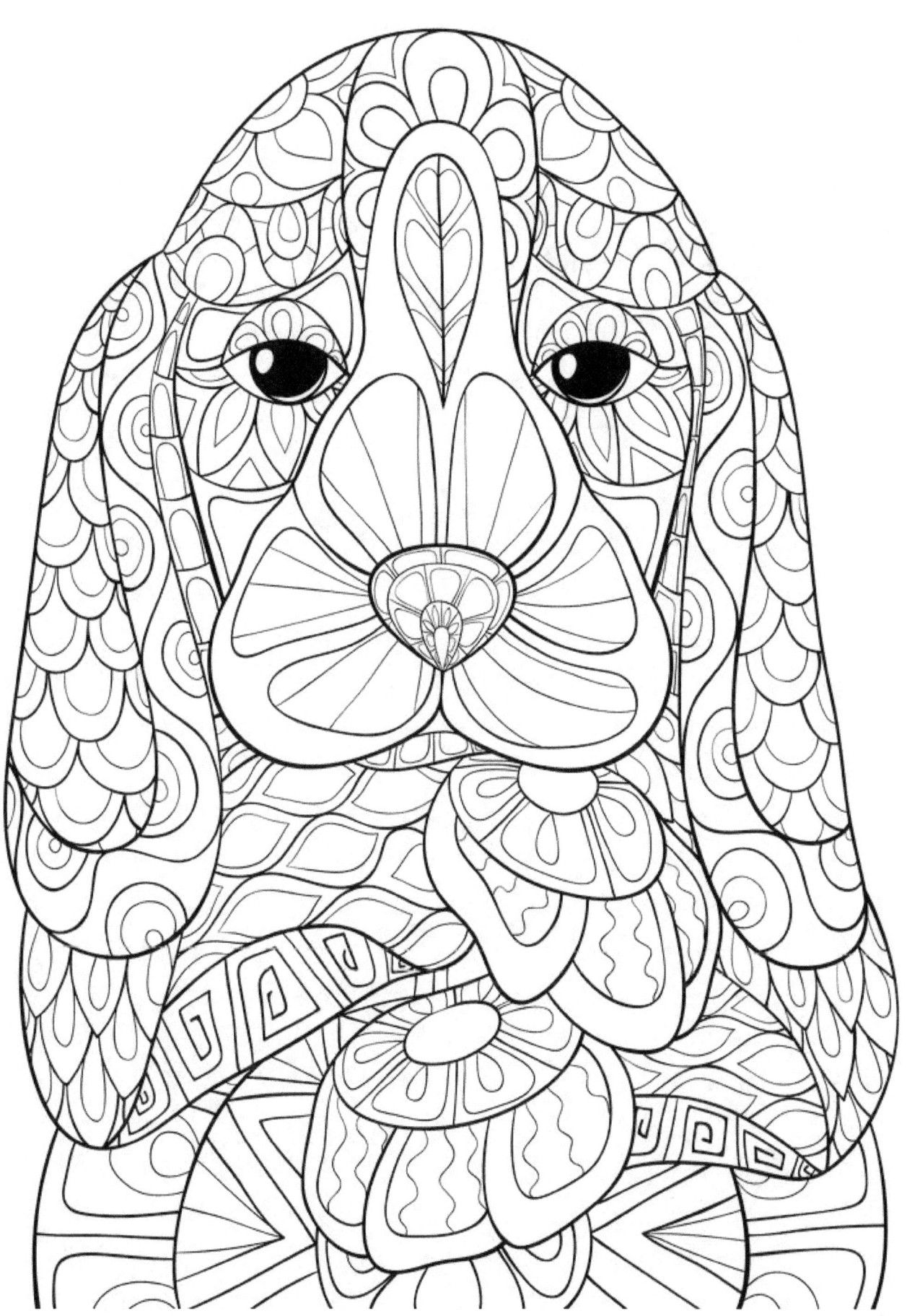

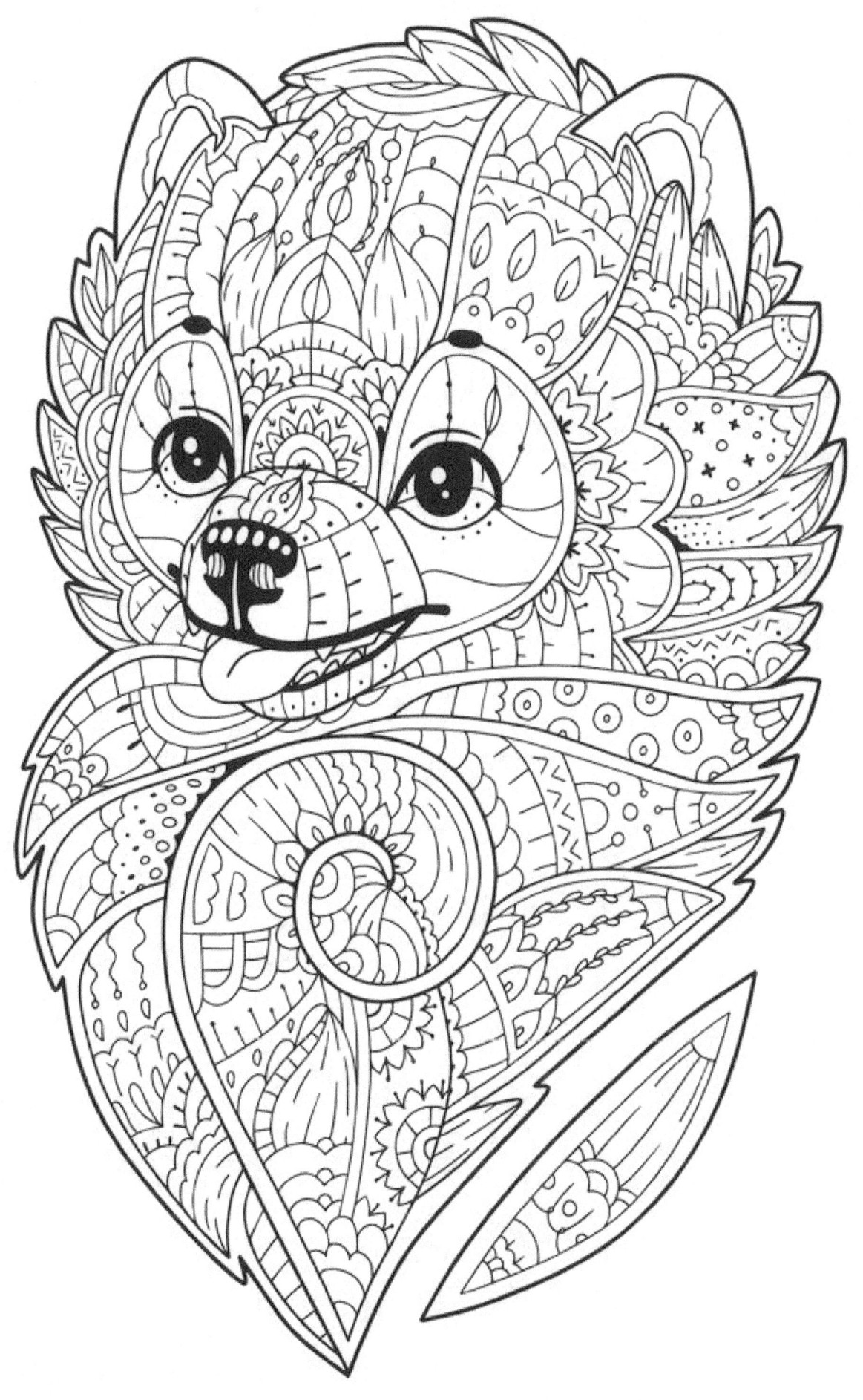

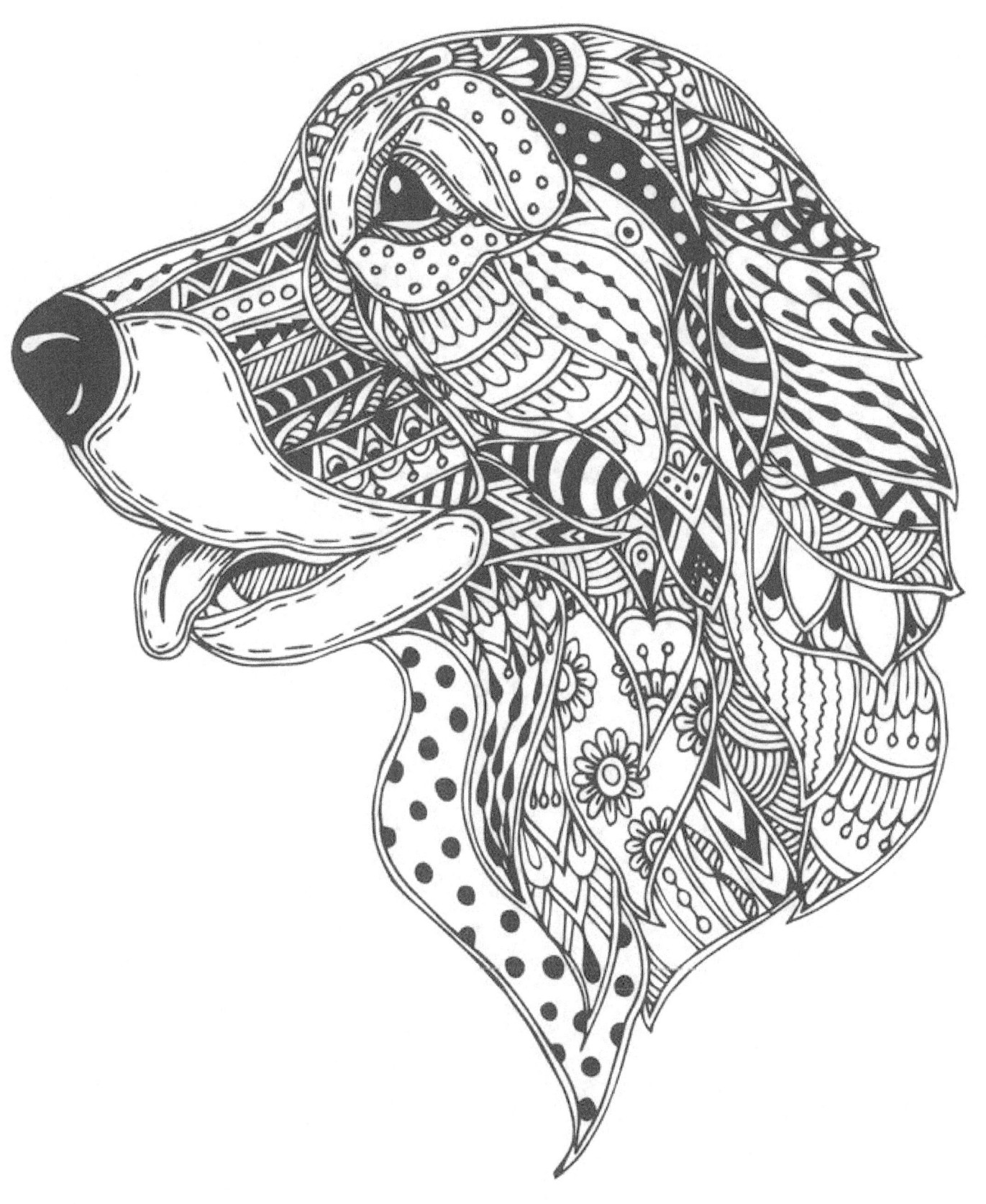

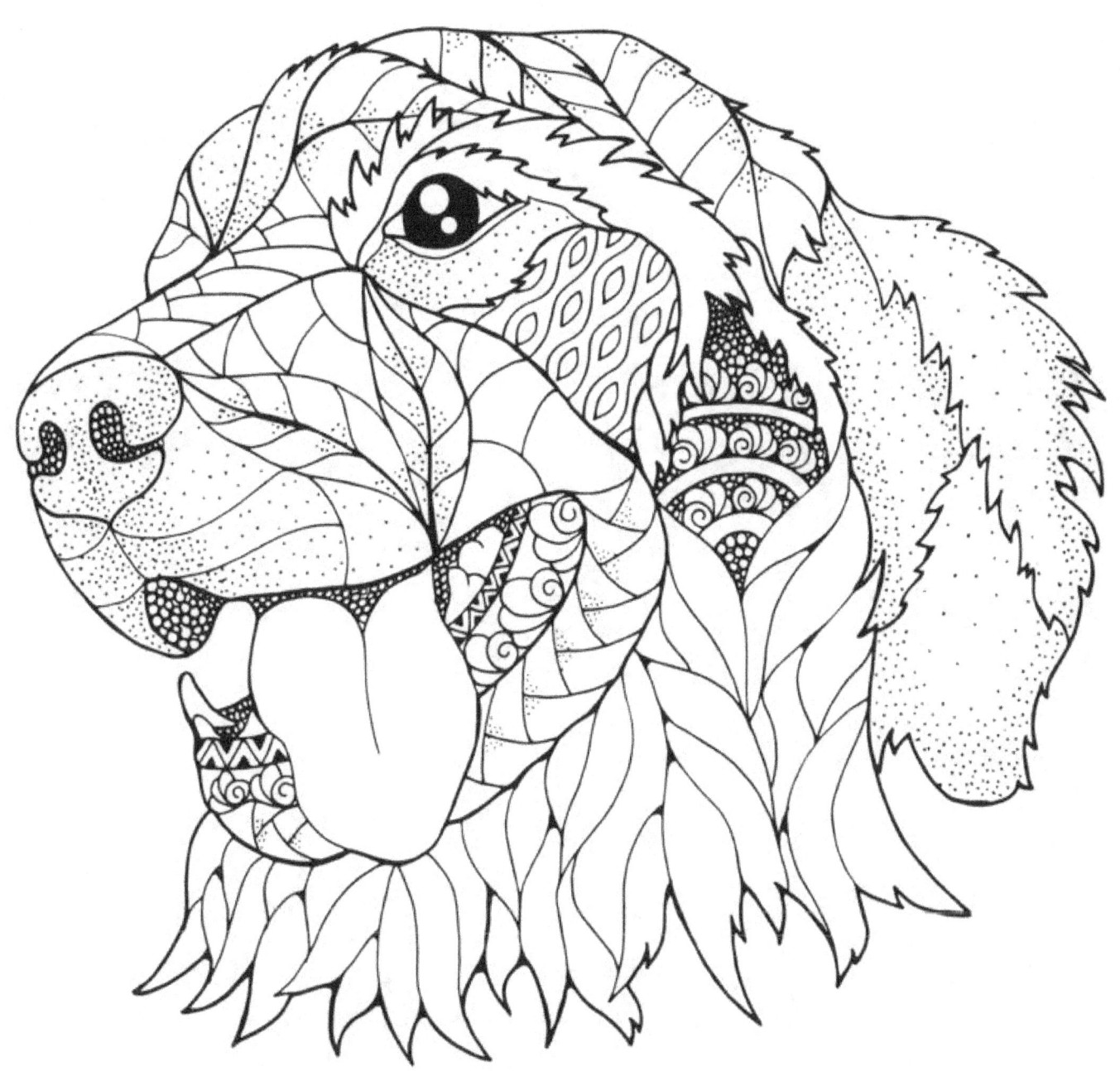

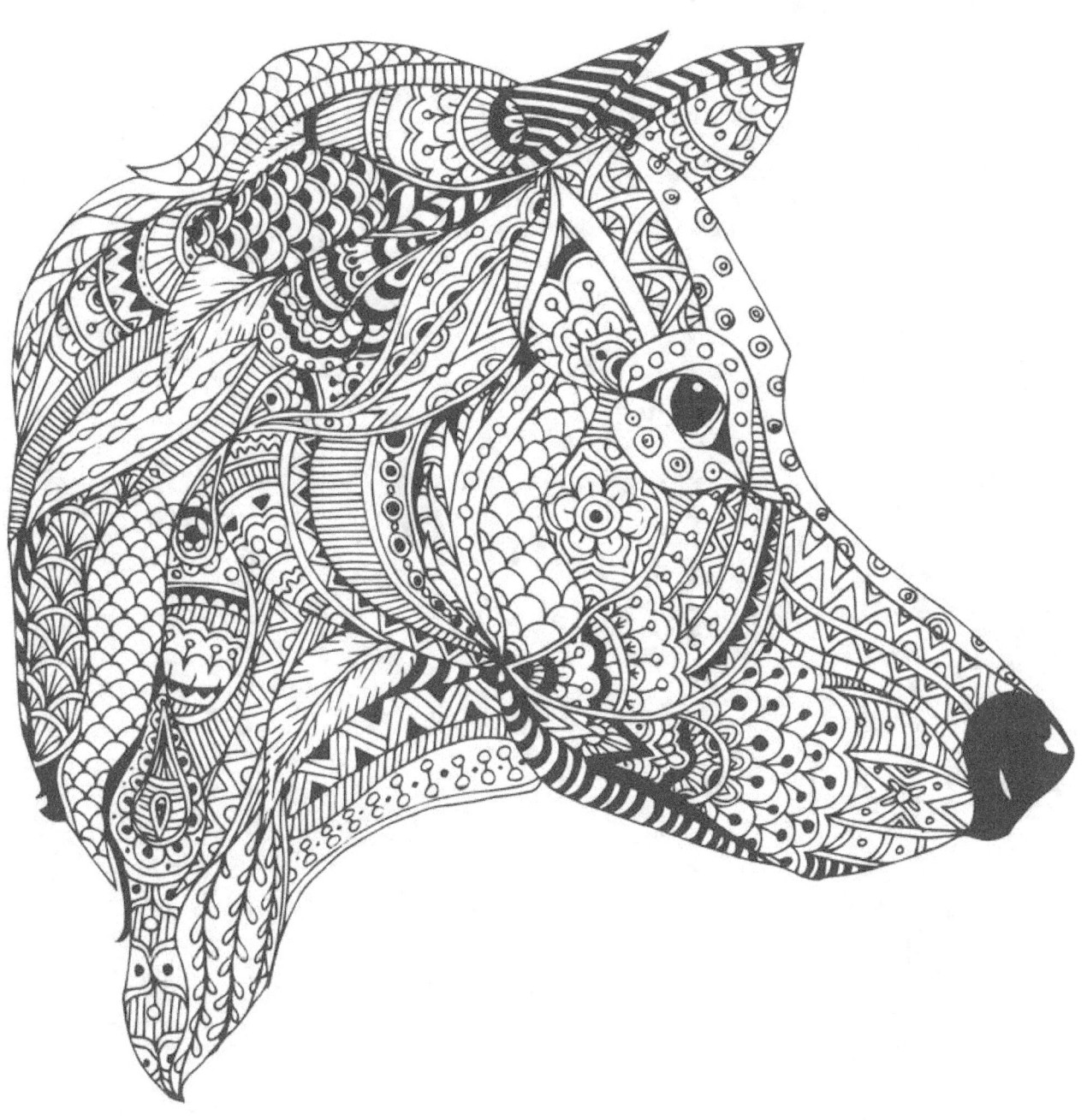

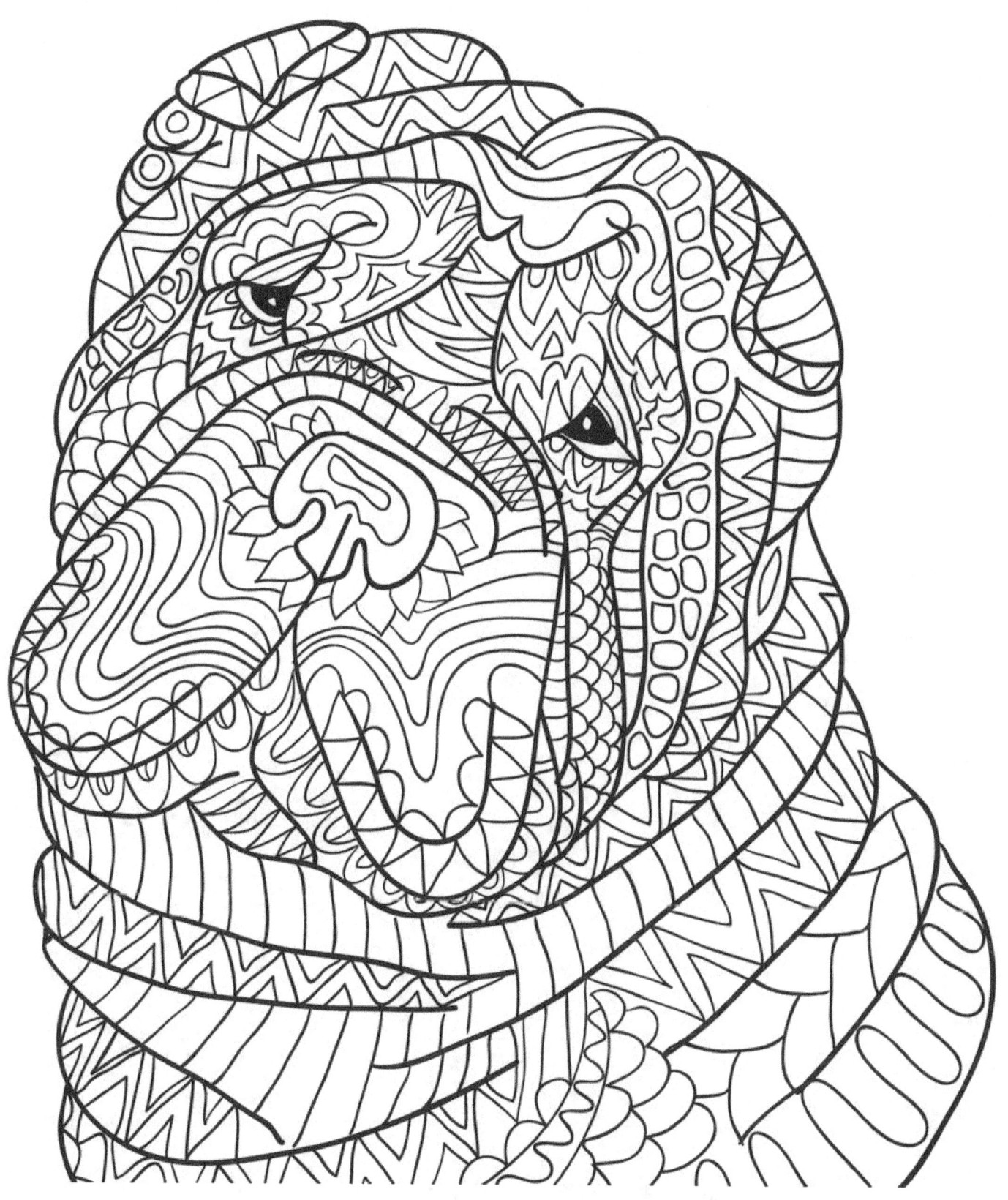

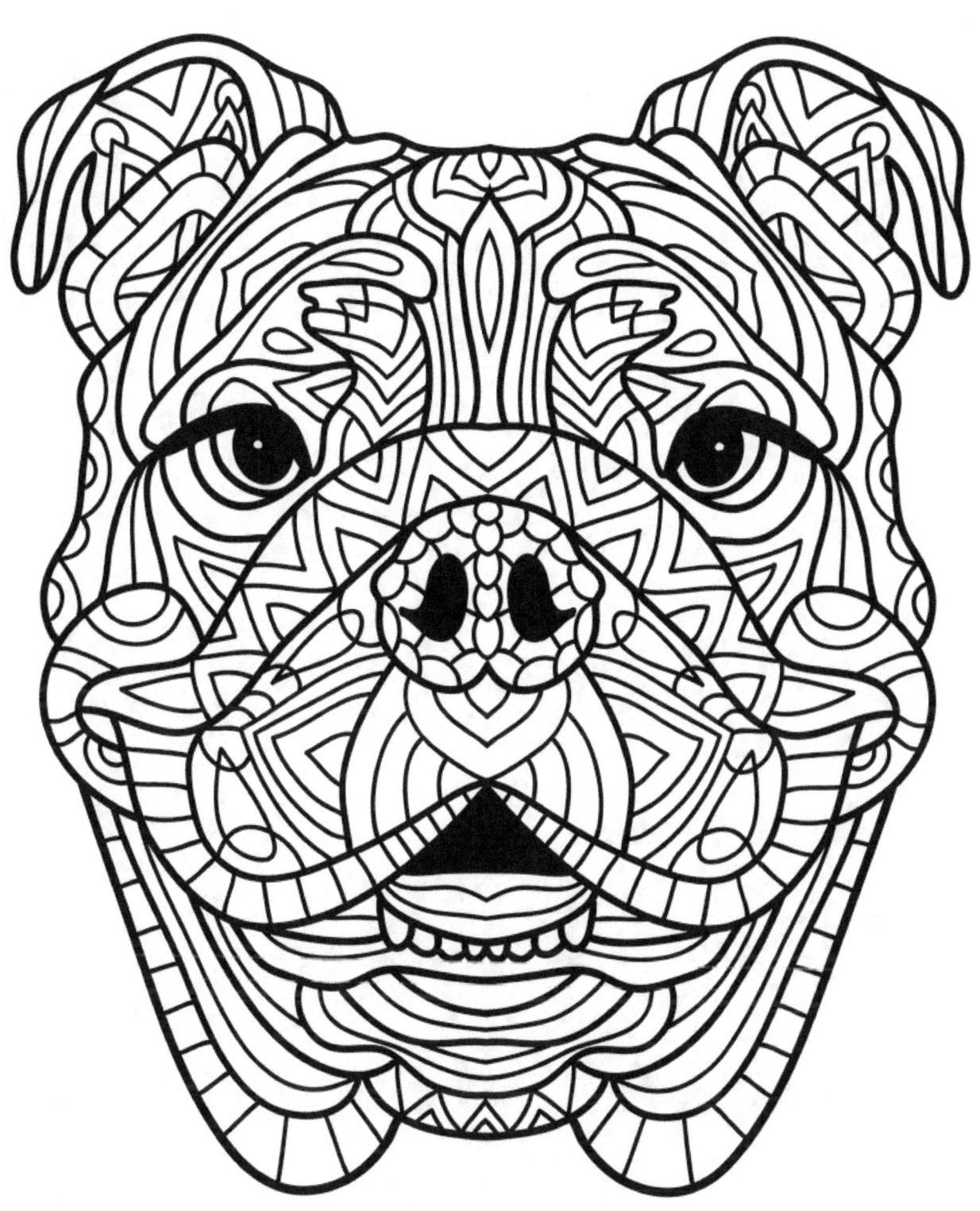

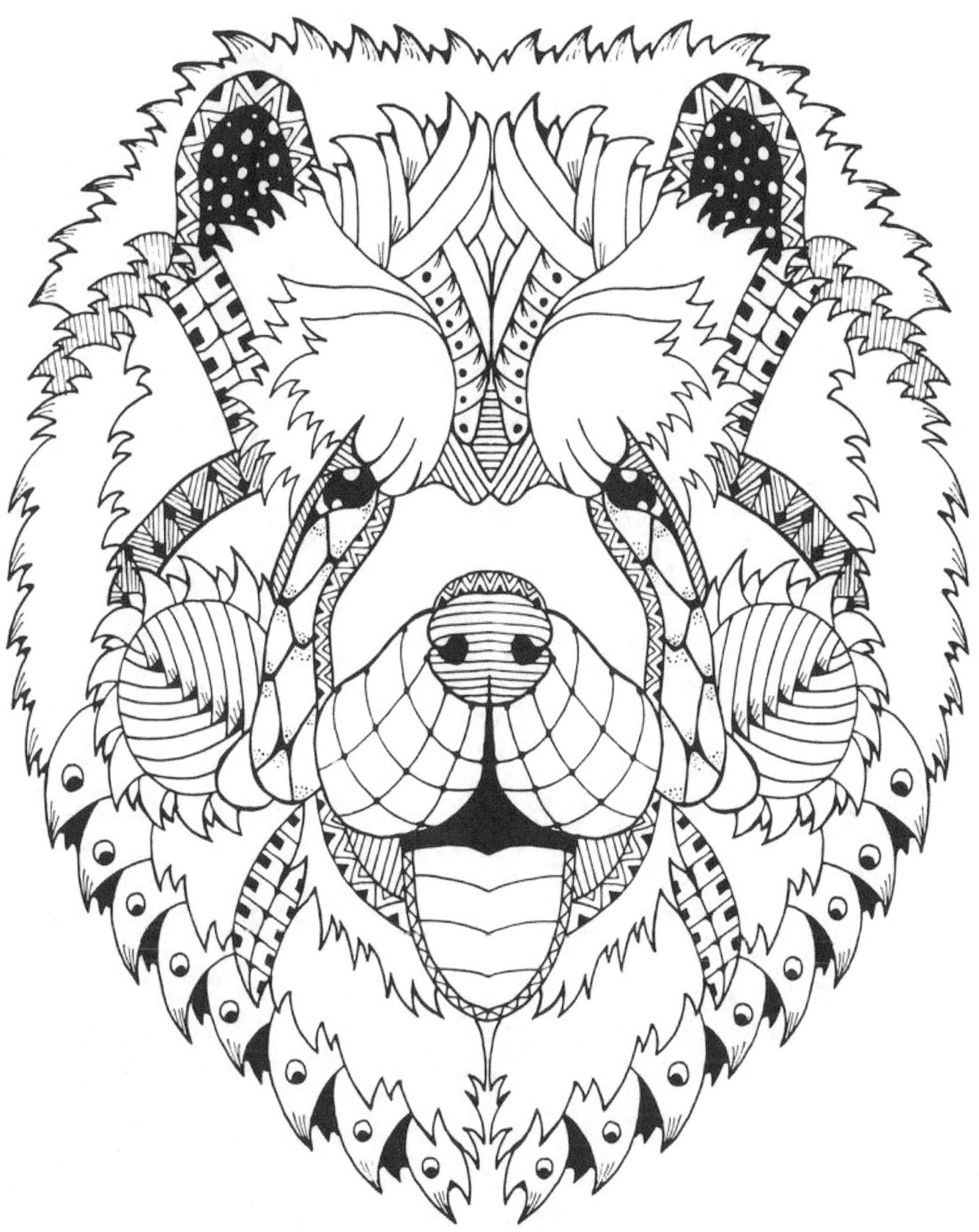

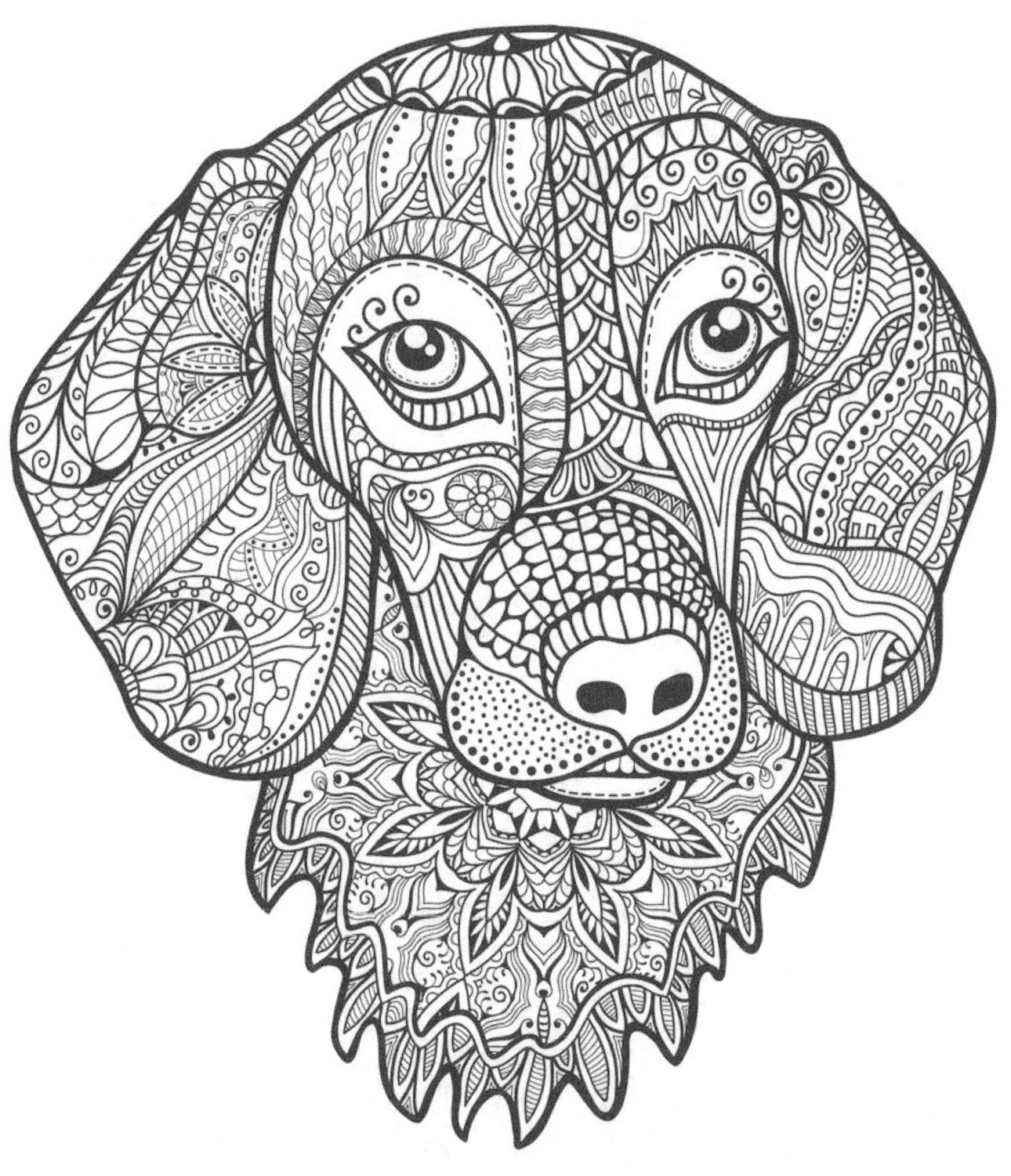

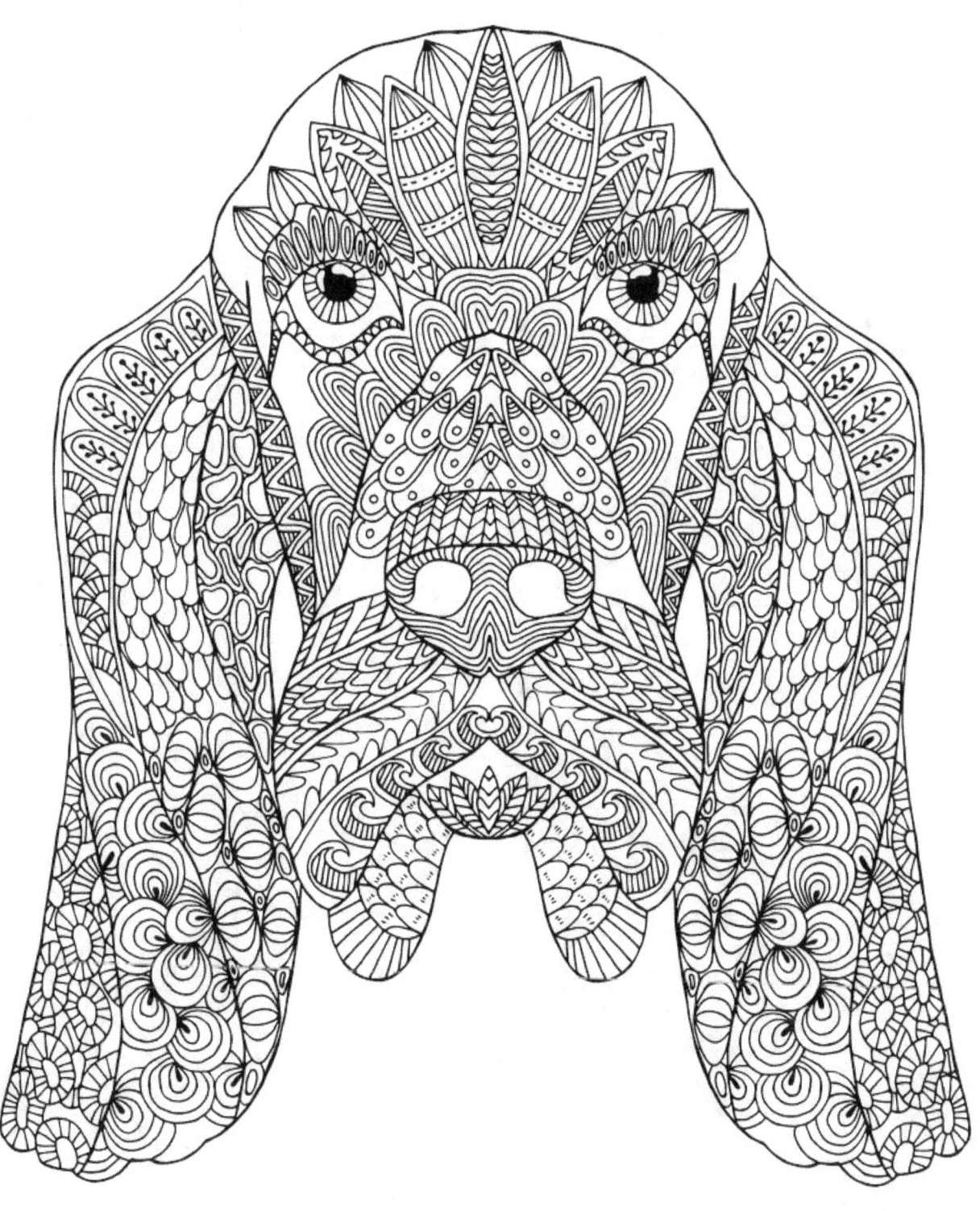